HOW TO PAINT WITH WATER COLORS

How to Paint

A BOOK FOR

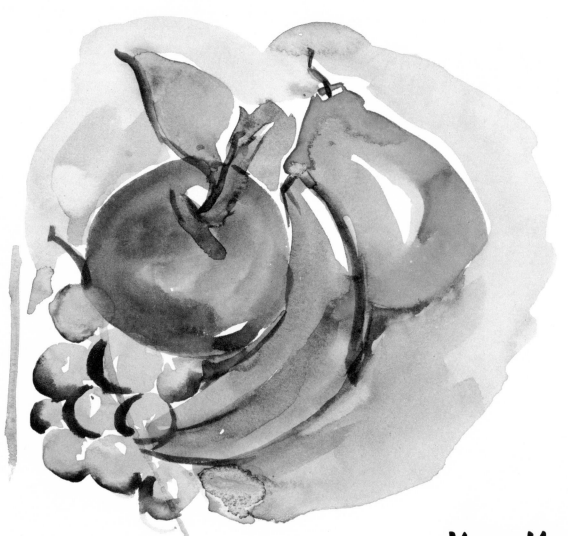

New York

THE VANGUARD PRESS, INC.

with Water Colors

BEGINNERS *by*

Arthur Zaidenberg

AUTHOR OF "HOW TO DRAW PEOPLE,"
"HOW TO PAINT IN OIL,"
"HOW TO DRAW CARTOONS," ETC.

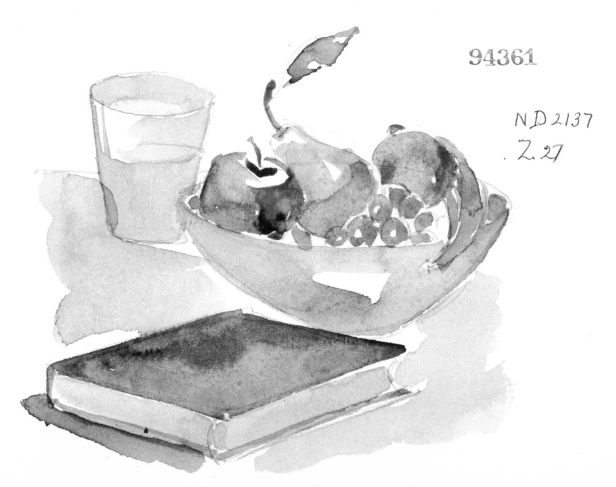

WATER-COLOR PAINTING

Water colors are the most widely used of all coloring techniques. This is the case for a number of reasons.

One can buy an inexpensive box of six or eight "cakes" of water-color pigment and, with a few camel's-hair or sable brushes, a glass of water, and almost any kind of paper, one is ready for painting at small cost and little trouble.

Water-color painting is a familiar medium of art expression. Every child in earliest school days has tinted pictures in coloring books and colored miles of scrap paper with crude trees, animals, and people. We are all at home with water colors.

Later, in school, we all made posters for one reason or another—school elections, anti-litter campaigns, and so on. In these cases we used poster colors, which are opaque, thick paints already mixed in jars.

Those of us who went on because of our special interest in painting used casein, tempera, and gouache.

Whichever paints of the water class were used, we found them to be brilliant, luminous, and beautiful.

We see fewer water-color paintings in museums and exhibitions because oil paintings are more durable, more able to survive hundreds of years of weather and wear. But water colors will always be popular because beautiful results can be obtained with them, results quite different from those when oil paints are used.

Here we shall discuss and demonstrate the use of the varieties of water colors.

The results you will get from your use of these delicate pigments will be different from mine or anyone else's. This is inevitable because you are you and the sensitivity of water colors shows particularly your own "handwriting."

Study the methods explained in these pages, but be yourself and practice and experiment.

You may make very fine water-color paintings or merely pleasant ones, but, whatever the results, you will have great fun doing them.

MATERIALS

It is fine to have the best, most expensive water colors and brushes, but fine paintings have been made with five- and ten-cent-store art materials.

There are a great many different colors and you will try many as you go on with your art career, but it is well to start with a limited number of basic colors. Tube colors are best: White, Ivory Black, Cadmium Yellow, Ultramarine Blue, Green, Vermilion, and Alizarin Crimson.

BRUSHES

About four brushes are all you need for most water-color painting:

1. A large camel's-hair brush for flowing broad washes of color in the large areas of your painting.

2. Three sable-hair brushes, from a fine-tipped tiny brush to a relatively broad round-tipped brush.

There is no "right" way to hold your brush. Any position you find most comfortable is the one to use.

When you are through painting for the day, wash your brushes in warm water to remove all paint. Wipe the bristles of the brushes with a clean rag and put the brushes carefully in a tray so that the brush hair is not squeezed or twisted out of shape.

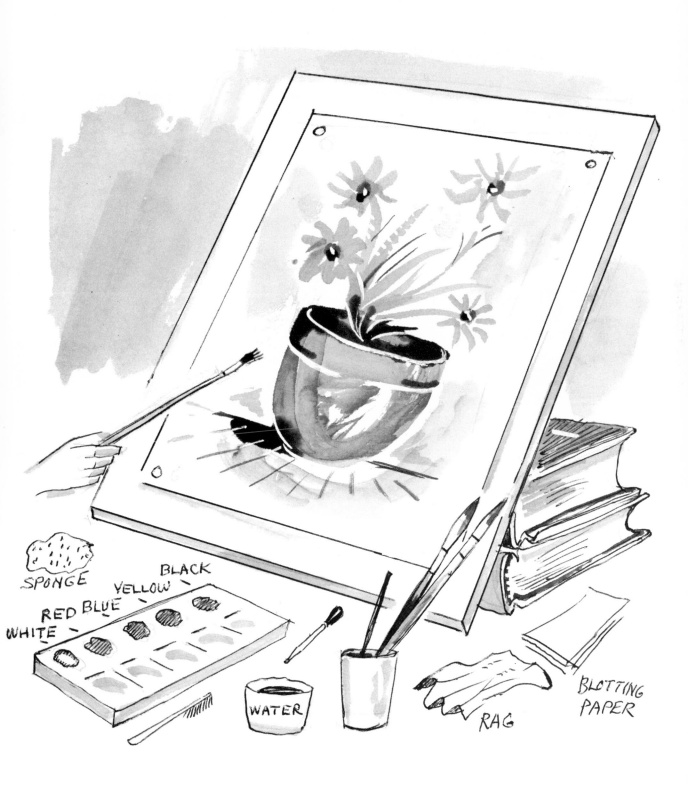

SPONGE

BLACK

YELLOW

RED BLUE

WHITE

WATER

RAG

BLOTTING PAPER

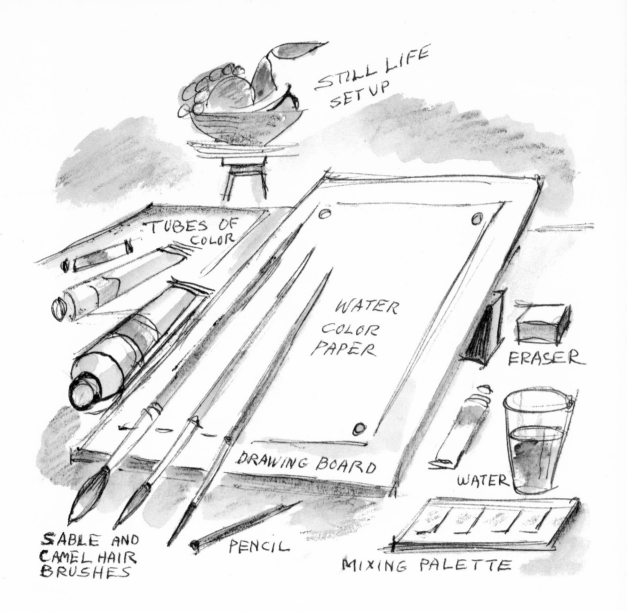

Still Life Set Up

Tubes of Color

Water Color Paper

Eraser

Water

Sable and Camel Hair Brushes

Pencil

Drawing Board

Mixing Palette

PAPER

Your water-color paper should have some texture on its surface and also be of sufficient weight to absorb wet flows of colors and not shrink or buckle.

The size of the water colors you paint should be neither too small nor too large.

Paper about 12″ x 14″ will furnish you with a scale large enough for doing justice to most subjects.

You should have a flat drawing board upon which you can thumbtack your water-color paper.

Your board should be tilted somewhat so that your wet washes of color will not lie on the surface in puddles.

COLOR

The primary colors are red, yellow, and blue. They are called "primary" because they are the base for all other colors.

With these primary colors and white you can mix thousands of other colors.

Diluted with water, these thousands of colors may be made into many more thousands of hues and tones of those colors.

Red, yellow, or blue, the primary colors, mixed in equal parts with one another, produce three additional colors:

> Red and Yellow make Orange
> Yellow and Blue make Green
> Red and Blue make Purple.

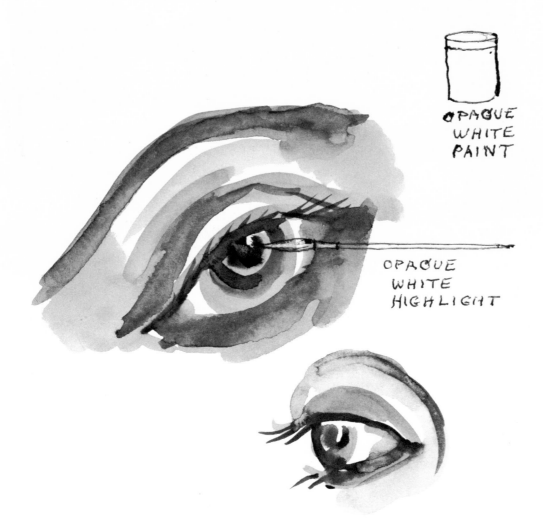

OPAQUE WHITE PAINT

OPAQUE WHITE HIGHLIGHT

There are two kinds of water-color paints: transparent and opaque. They are both called water colors because they are soluble in water. But true water-color painting is the transparent "wash" of color, in which the gleaming white of the paper beneath shows through, creating a glow to the painting.

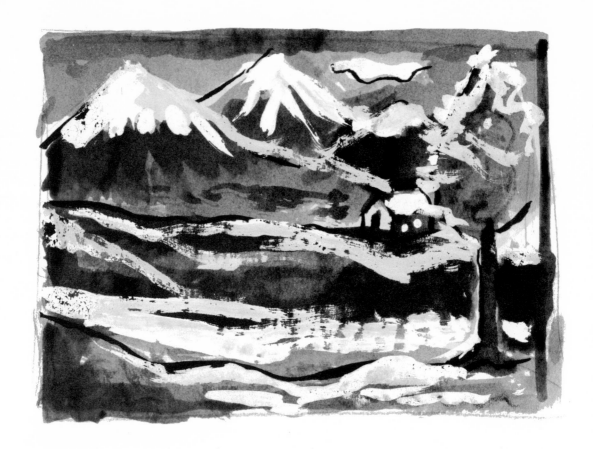

DRAWING FOR WATER-COLOR PAINTING

Make your underdrawing in very light pencil lines on the water-color paper. You must not make the drawing in too much detail or make many heavy lines because they will, of course, show through the transparent color. A "true" water-color painting is made with the paint; the underdrawing should be only a few simple guidelines, as shown on page 36.

Practice drawing directly with your water-color brush as though it were a pencil. You will, of course, get broader strokes and the brush will be harder to control at first than the pencil, but you will soon find that your water-color sketches will have much more freshness than those you *filled in* on a pencil drawing.

Because water colors are most beautiful when they are applied spontaneously, with the least amount of "overworking," you should be sure of what you are going to paint and how it will be "composed" on the paper.

Your guideline drawings should serve as a plan upon which you can work freshly and swiftly. Water colors dry quickly and you must paint freely in order to keep your painting fresh-looking.

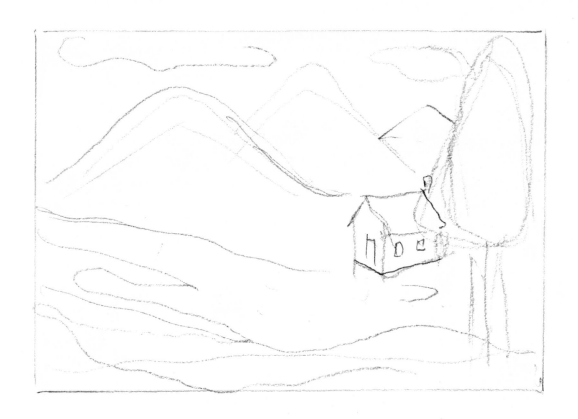

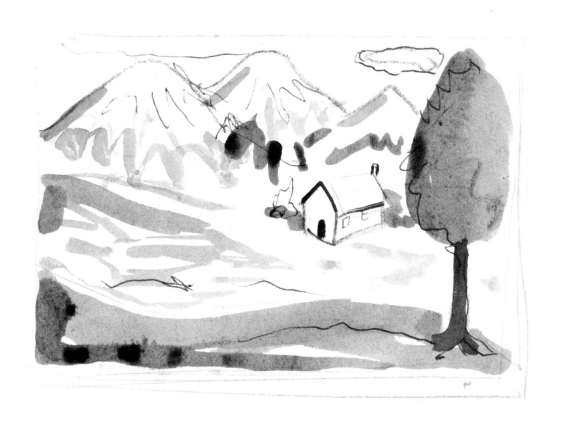

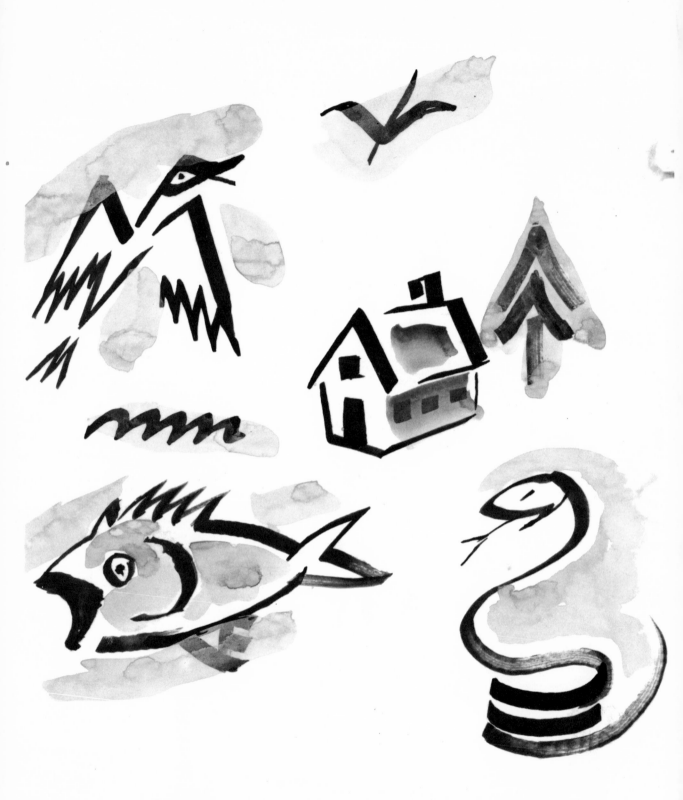

THE WET- AND DRY-PAPER METHODS

After the sketch has been lightly drawn on the water-color paper, two methods may be used to produce lovely effects—the wet- and the dry-paper methods. In some cases the two are used in the same painting.

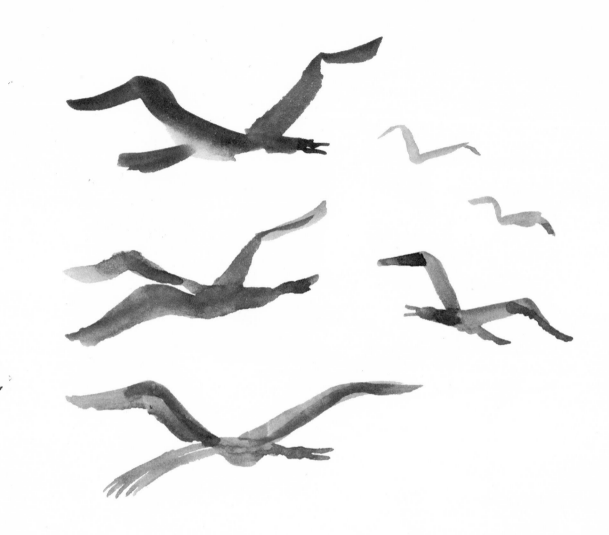

In the dry-paper method the water colors are applied directly to the dry surface.

In the wet method, a clear water cover is flowed onto the paper (generally by brush or sponge), which has been mounted to the drawing board with thumbtacks. When the paper has absorbed the water and is in a damp state, the painter can begin applying colors onto its surface. All the edges become soft and beautiful.

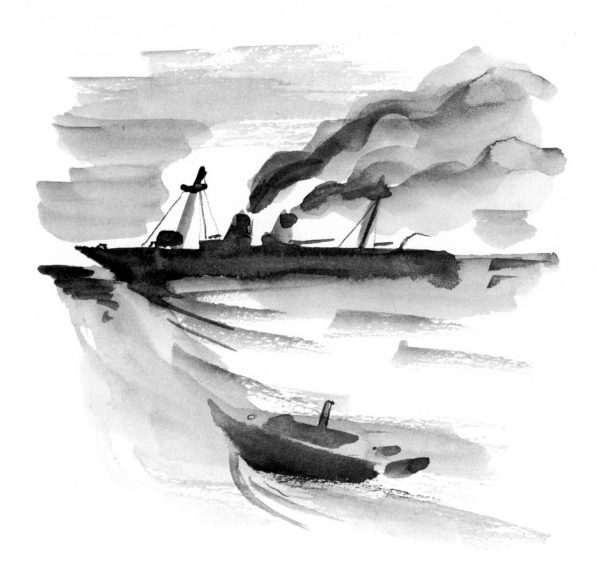

Very wet and almost dry brush combined.

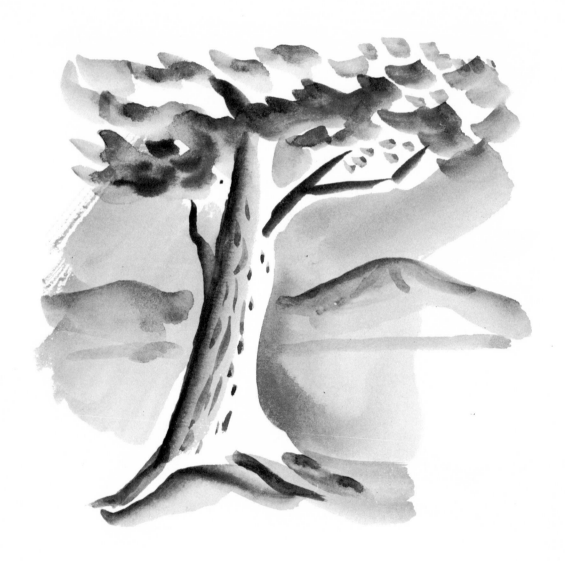

The pictures on these pages show the difference between the wet- and dry-paper methods.

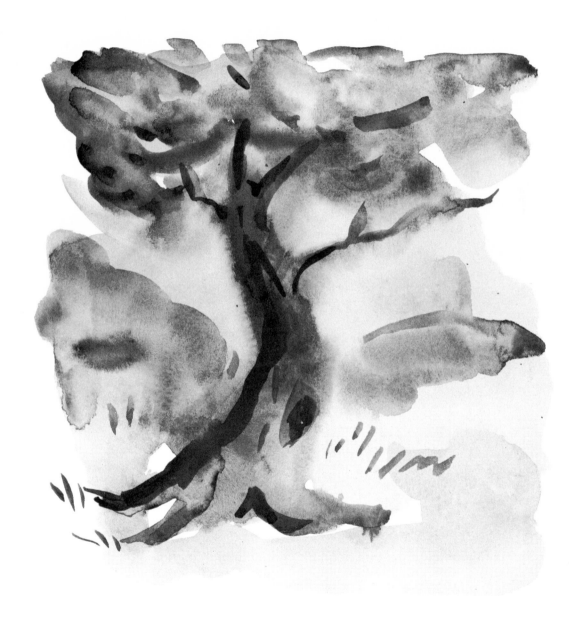

This tree shows the soft blending obtained by painting on damp paper; the tree opposite shows the sharper edges of the dry method.

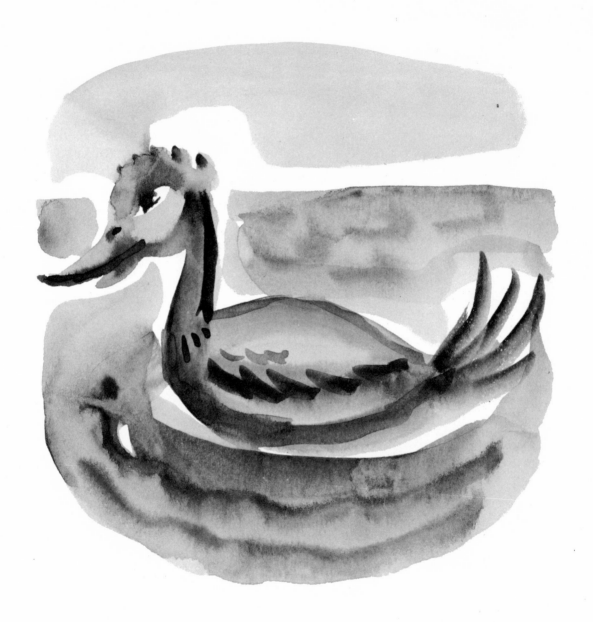

This duck was painted with the "wet" method.

A flow of clear water was first applied to the paper upon which a very light pencil drawing was already made.

When the surface was still damp, the duck and waves were painted.

This produced that soft, watery quality so unique in this beautiful medium.

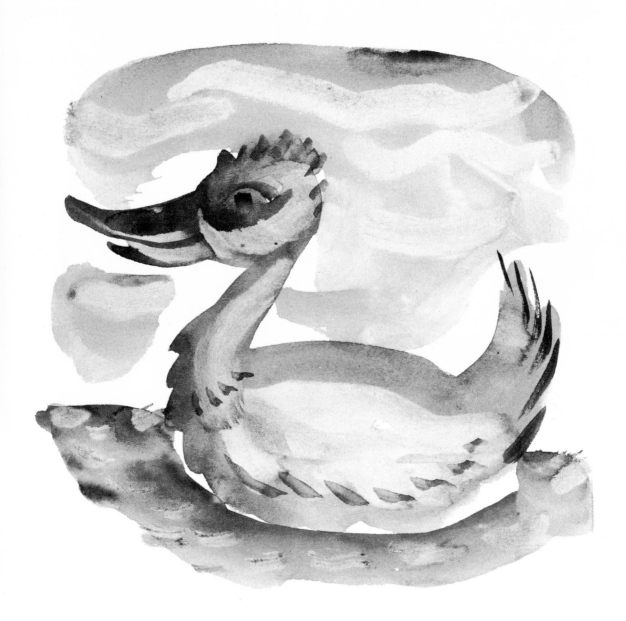

This duck was painted with the paper surface dry.

 The variations of light in the sky and water and parts of the duck were obtained by wiping the wet paint with a dry bit of absorbent tissue at those points.

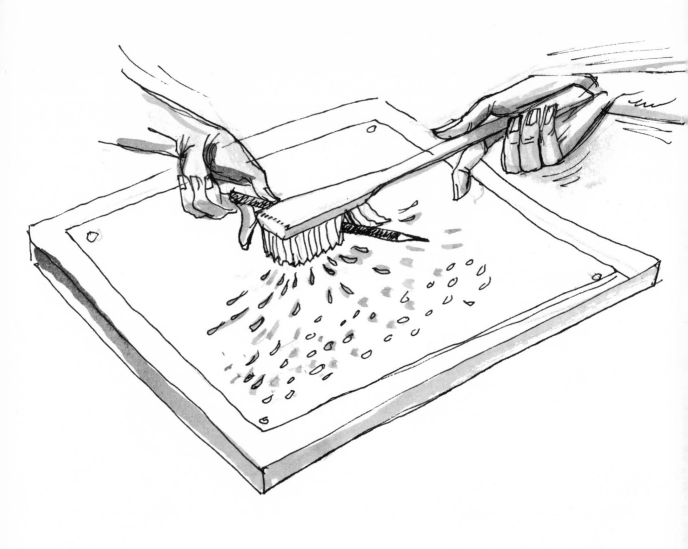

Saturate an old toothbrush in diluted color. A pencil rubbed along the bristles will spatter a pattern of color dots on your paper.

For an even expanse of color dots, tap the paint-saturated brush gently on the paper.

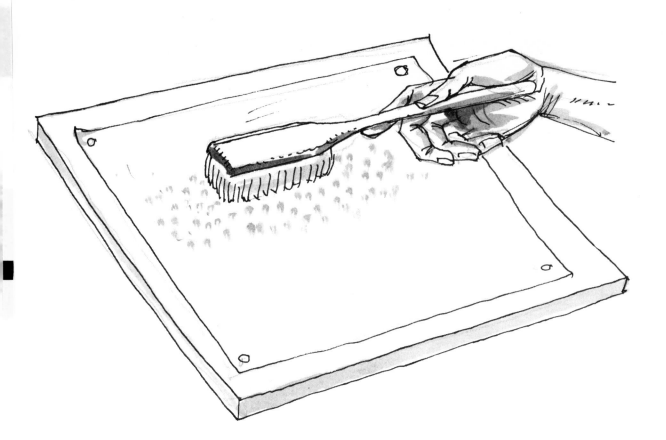

One of the many lovely things about painting is that there are no hard and fast rules and there is no *one* way of using your materials.

The fact is that, as you go on with your art studies, you will probably invent a few tools of your own that will serve your special needs.

Toothbrushes (old ones) are used for scumbling surfaces or for spattering paint in little dots of color.

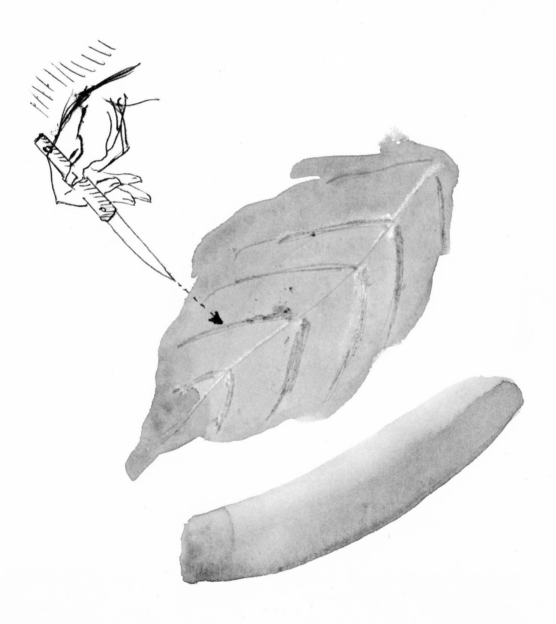

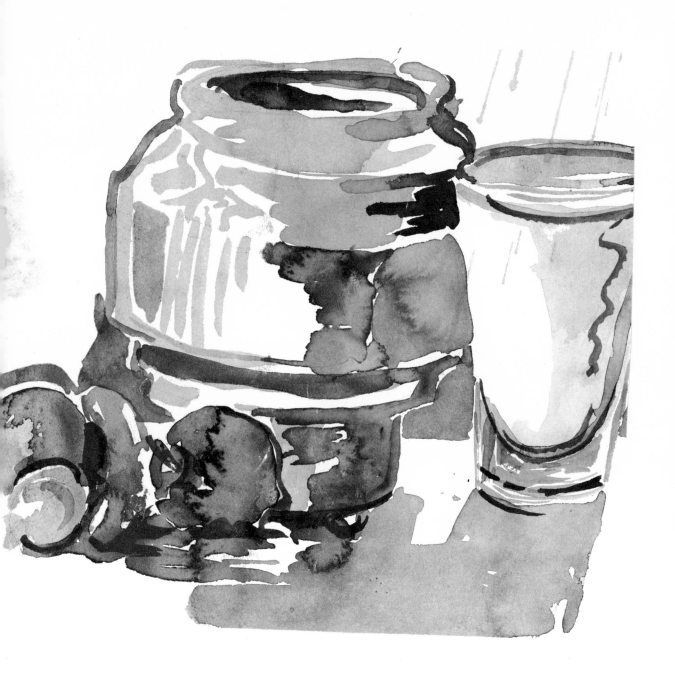

Some water-colorists use sponges to blot out areas of their tones; others use scrapers made of wire brushes or even a toothpick or a knife to make white lines in a painted area. Blotting paper, tissues, and eyedroppers are often tools for the inventive artist. Anything is permissible that helps you say best what you want to say with your paints.

In no painting medium other than water color can the clear paper enter into the telling of the story with such effectiveness.

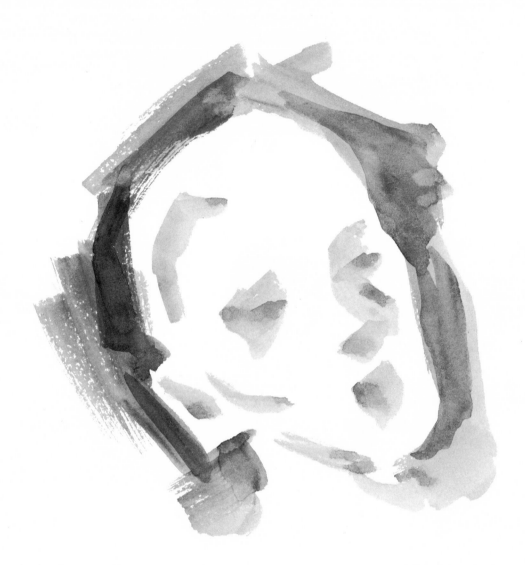

In this head, almost all the structure is "implied" by leaving the white paper untouched by the brush.

The black outline against the white background throws the white forms into relief, and the few strokes of the brush "suggest" the features—just enough for the viewer's imagination to supply the rest.

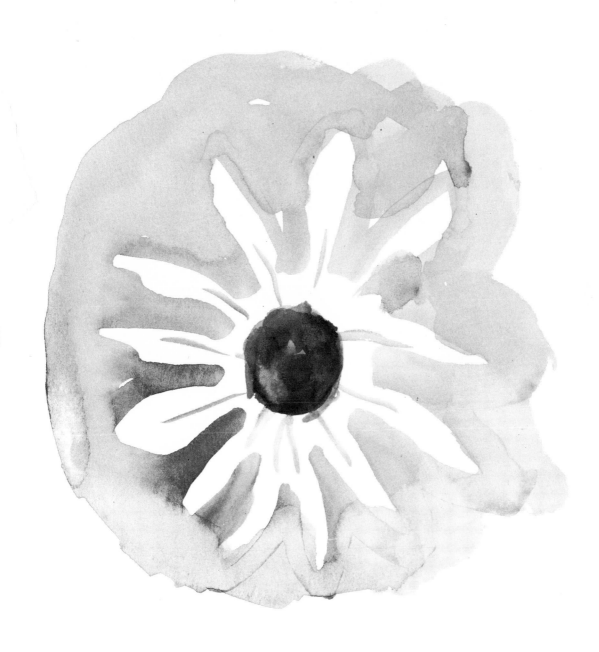

The areas that are untouched by the brush are often as much a part of the picture as those that are painted.

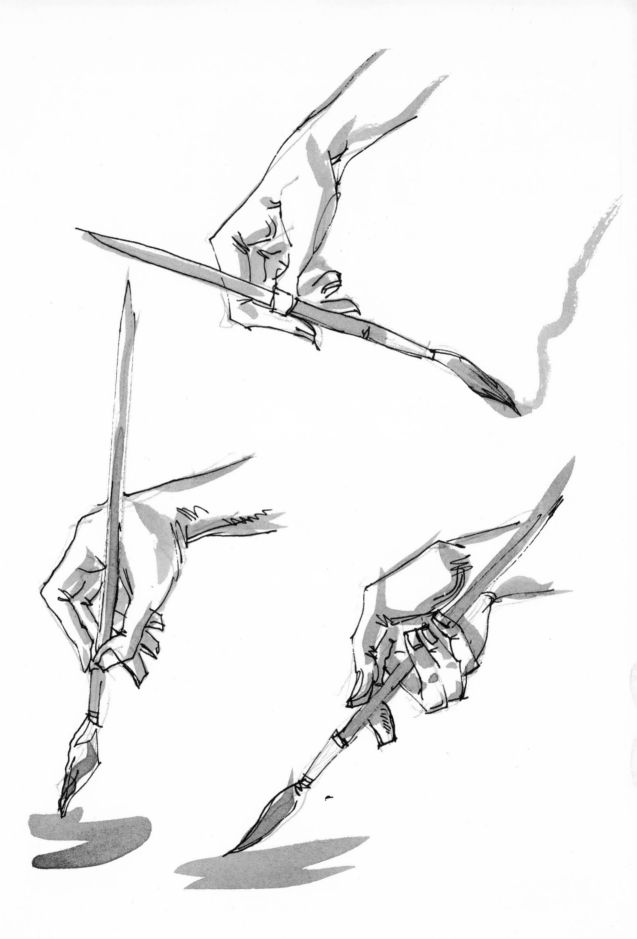

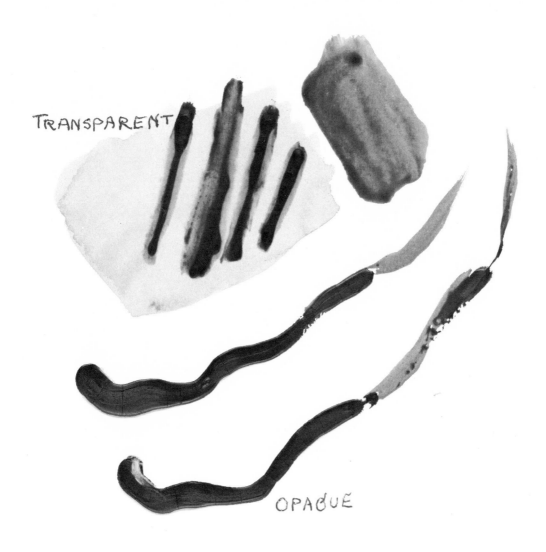

TRANSPARENT

OPAQUE

BRUSH STROKES

Your brushes are very sensitive instruments. They will respond to your every mood once you have learned their possibilities.

Saturated heavily with water and a light tint of paint from your palette, your brush will flow transparent "washes" on your paper. When your brush is only damp and richly steeped in color, the tones produced will be bold and heavy. Your pointed small brushes will give you fine lines of color. The amount of pressure you exert on your brush will determine the width of your strokes on the paper.

Practice will reveal to you the wide range of your brushes.

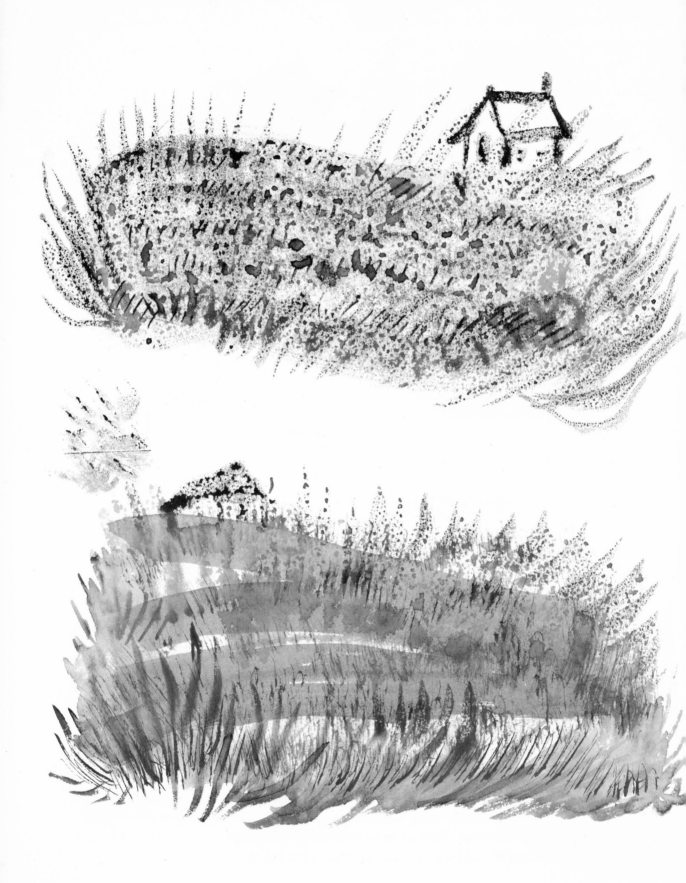

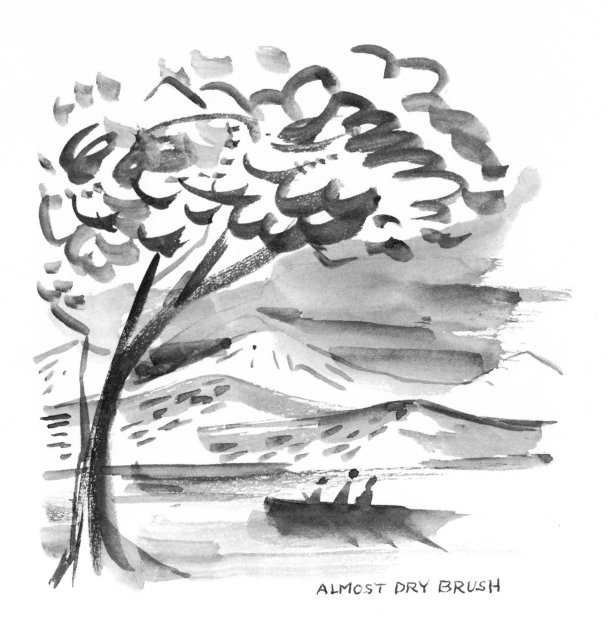

ALMOST DRY BRUSH

In the water-color sketches opposite, the brush strokes seem to fray off at their ends, leaving white paper exposed. This is accomplished by painting with a semi-dry brush. Many water-color painters like the sparkle this technique gives to their work.

In addition to practice, you can learn a great deal about the application of paint with your brushes through the study of works by fine water-colorists. Winslow Homer, John Singer Sargent, John Marin, and Thomas Eakins were brilliant American water-colorists. Raoul and Jean Dufy, the French water-colorists, have much to teach you about techniques of applying color.

Go to museums and galleries or study reproductions of the works of great water-colorists in books.

Inevitably you will learn a great deal from them and also have much pleasure in the process.

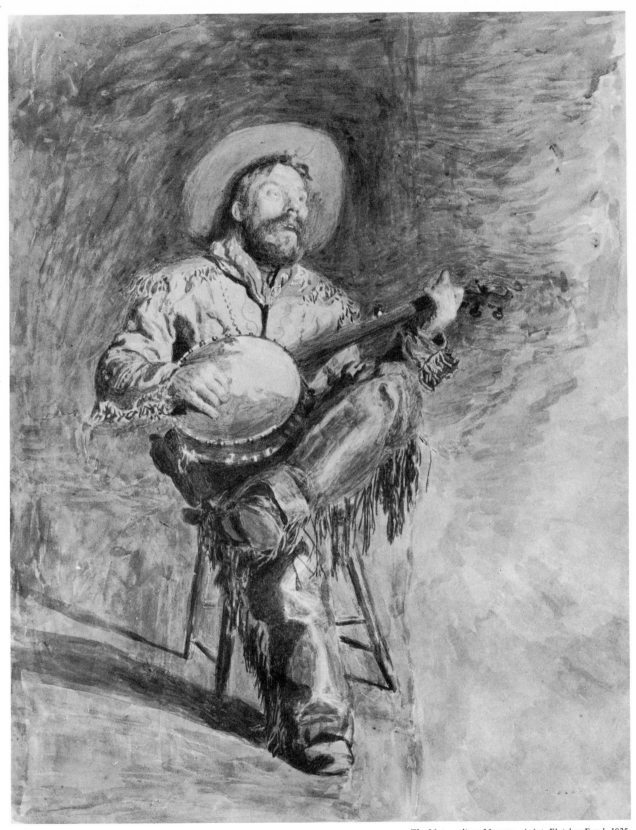

Cowboy Singing—Thomas Eakins

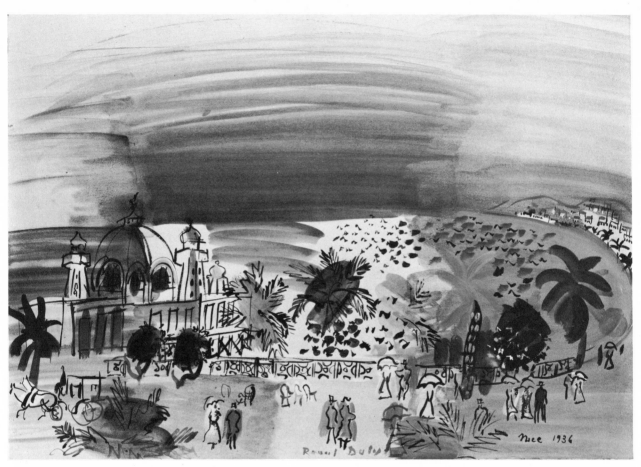

Collection, The Museum of Modern Art, New York. Gift of Fania Marinoff Van Vechten in memory of Carl Van Vechten.

Nice—Raoul Dufy

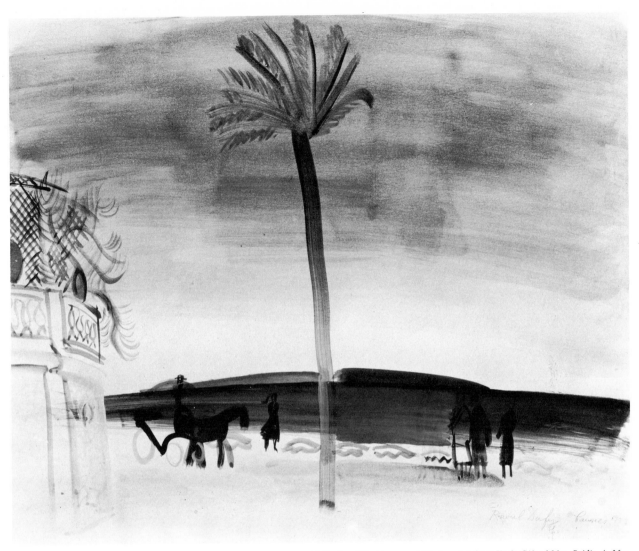

The Palm—Raoul Dufy

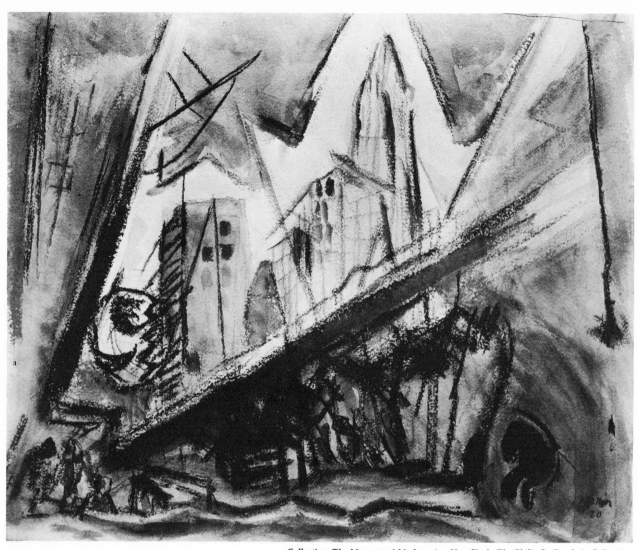

Collection, The Museum of Modern Art, New York. The Philip L. Goodwin Collection.

Lower Manhattan—John Marin

FLOWING A WASH

A "wash" is a smoothly flowed area of transparent color on your paper.

For flowing washes use your larger brushes.

Mix a generous amount of the required color in a saucer. Dilute the color with enough water to make the wash flow freely. Some water-colorists like to dampen the sheet of paper with a sponge before flowing the wash.

Pin your water-color paper to a drawing board with thumbtacks and tilt the board toward you at a thirty-degree angle.

Now, using a large brush dipped in the wash, apply smooth strokes across the top of your paper on the tilted board. The excess wash will flow down across the lower edge of your brushed stroke. Flow the next stroke through that pool and another pool will settle below. Continue smoothly until you have a broad, even area of wash over as large a surface as you wish.

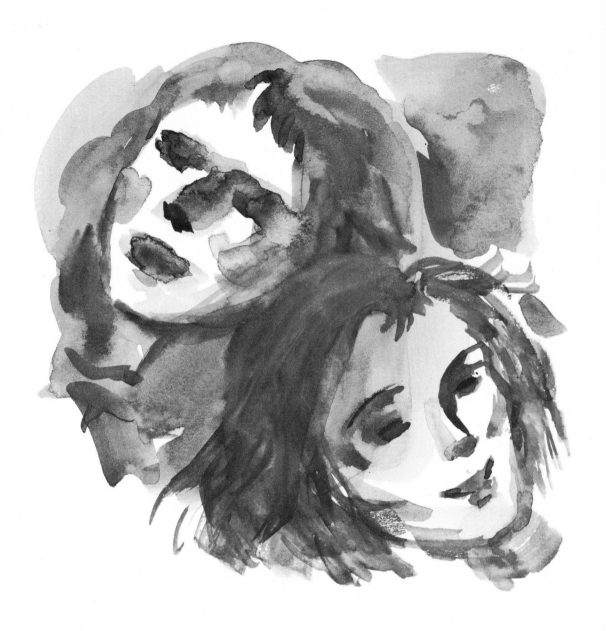

BLENDS

Blending two colors directly on your paper instead of on the palette makes for a fresher, softer joining, with tone variations that the ready-mixed palette color cannot give you.

As you go on with your studies and practice, you will soon learn to control these blendings so that they best serve your particular purpose.

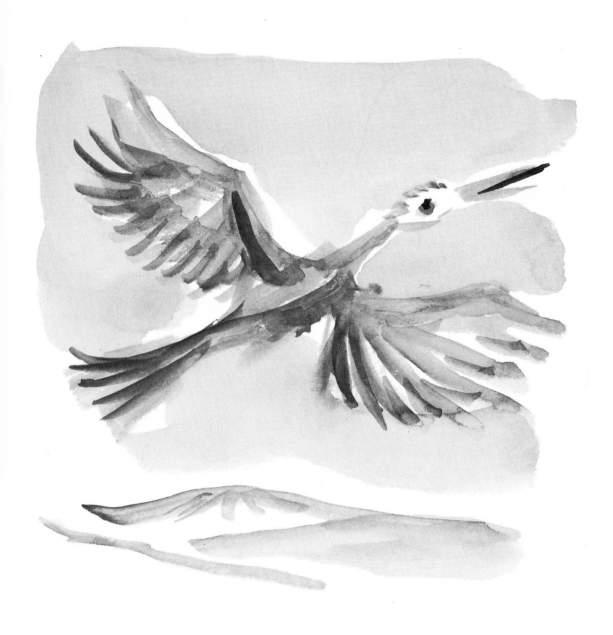

Your cup of water need not be fresh for each dip of the brush before each change of color but you·must not allow your dipping water to become so tinted with assorted colors as to affect the purity of color strokes on your paper.

Change your dipping water frequently.

One of the special virtues of water colors is their freshness.

The best water-color paintings look as though they were painted very quickly.

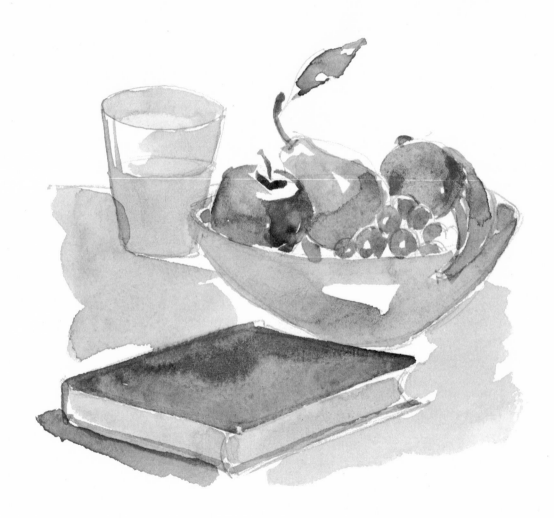

Though this may sometimes be the case, a good painting is never done in haste.

Prepare your plan of work, equip your working area, decide what you want to say, and how you wish to say it. Then, when you are quite ready, the painting that results will have that very desirable quality of spontaneous freshness.

Try to keep your materials few in number, always clean, and easily available for use whenever the spirit moves you to paint.

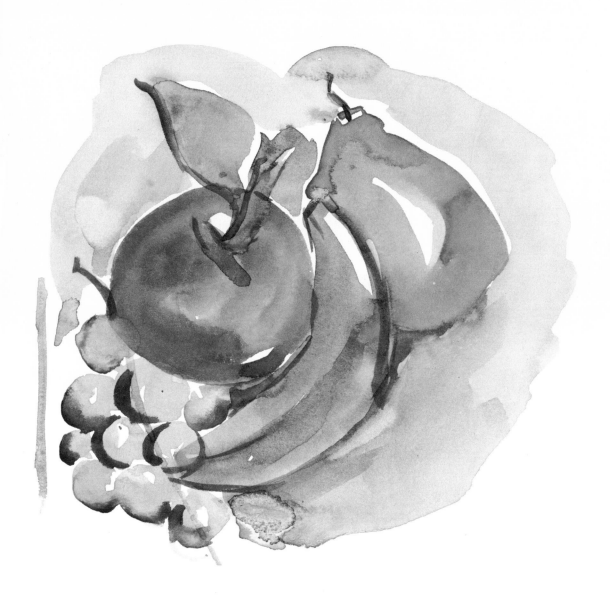

The darks and the detail are the final additions to your painting.

Water colors used in their best manner are not intended for painting in great detail, although many fine artists have made remarkably detailed water-color paintings.

However, for your purposes here, it will help your studies if you choose subjects that call for large, simple areas painted in broad, fresh strokes of your brush.

PAINTING A LANDSCAPE

Here are three stages of a simple landscape.

Do not make a more elaborate pencil guide than this one—if possible make even fewer guidelines. Remember, your water colors are transparent and your drawing will show through.

Broadly lay in the light areas in soft, diluted tones of color so as to keep the sparkle of the white paper beneath.

Now proceed to put in your next range of tones, the somewhat darker ones.

Avoid the small details, working clearly and freshly with your middle-tone washes.

Some of these will flow over the first washes. If they are both wet, they will blend and form a third color, as indicated on our mixing chart.

The following two stages of a water-color sketch of a boy painting outdoors was done with great freedom after careful planning.

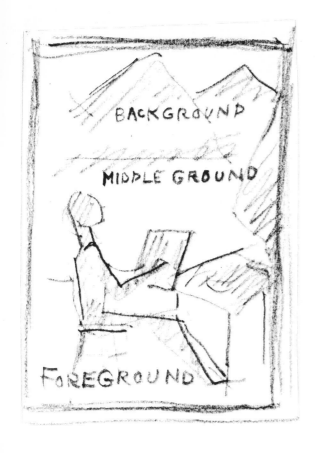

On the damp surface, with your sable brush saturated with the color you choose, flow in the light areas. When you can use the clear white of the paper to advantage, leave it untouched by the flow of color.

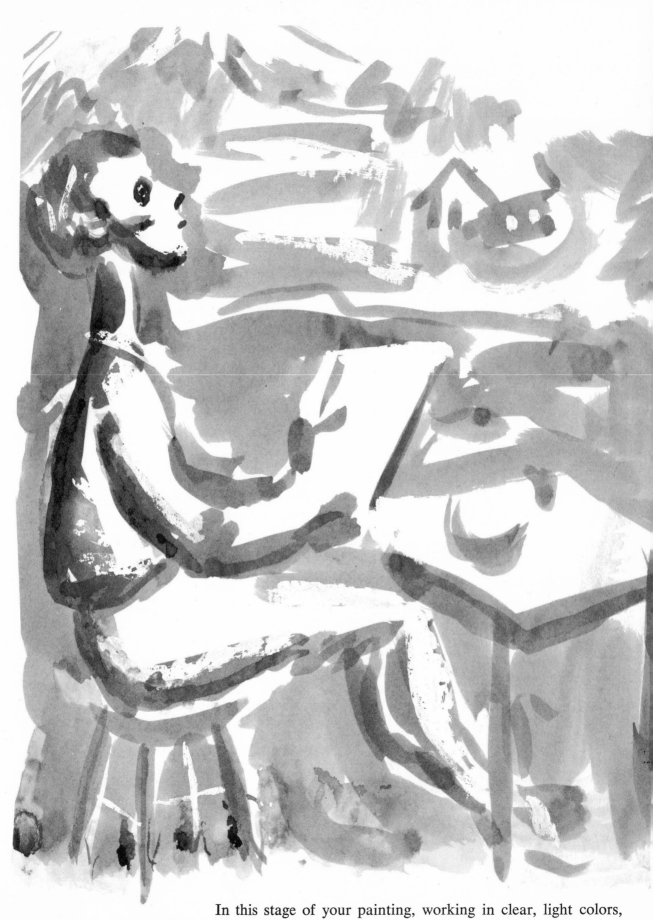

In this stage of your painting, working in clear, light colors,

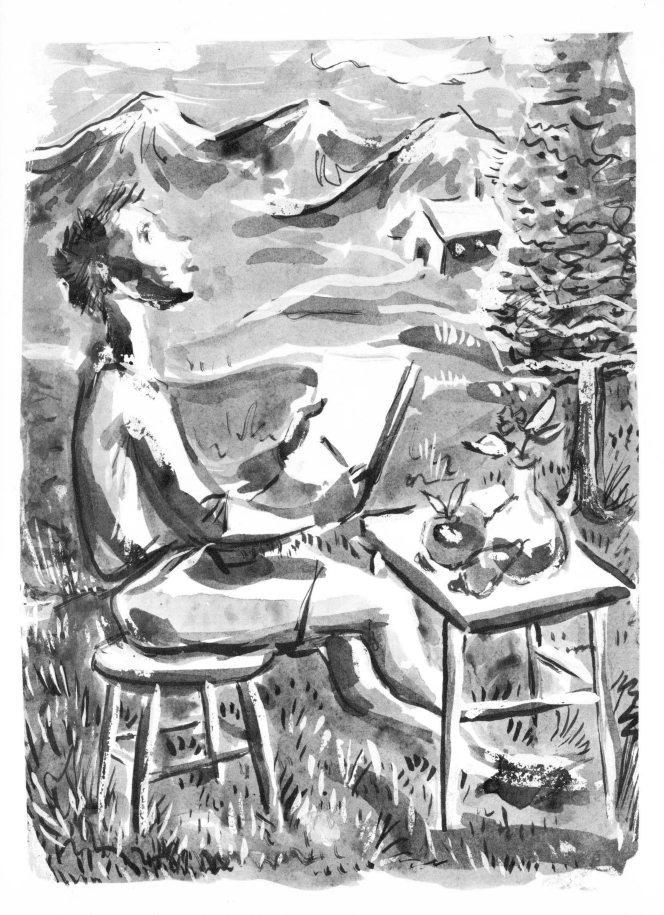

paint your large areas of color first.

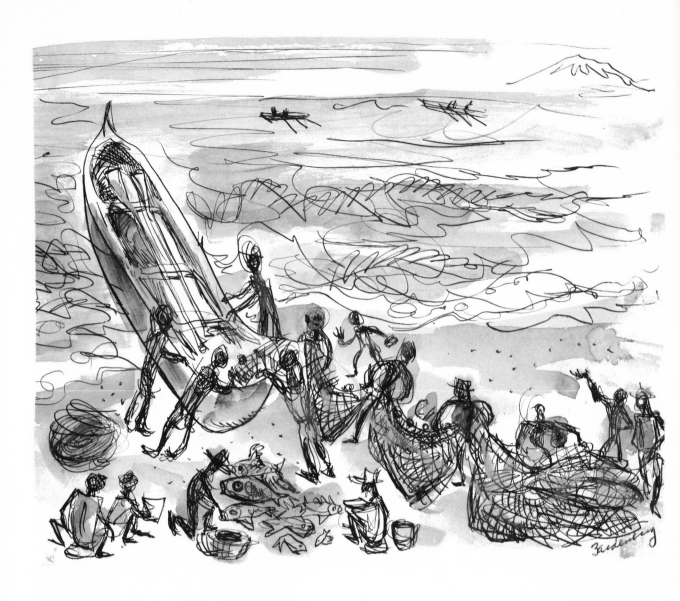

This sketch is really a tinted drawing.

Here is a sketch with almost no underdrawing.

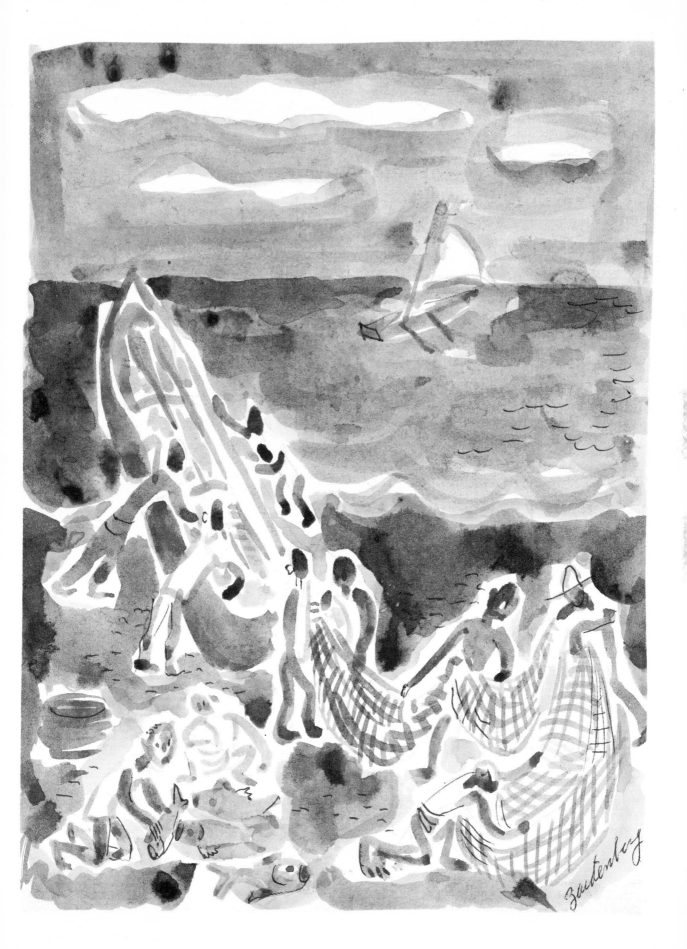

In the final stages of your water-color sketch you must build with a series of darker and darker films of color, one over another, until you achieve the depth of tones required.

Applying the dark areas in layers of tone will give those areas more vibrance than they have when the color is directly applied in full strength.

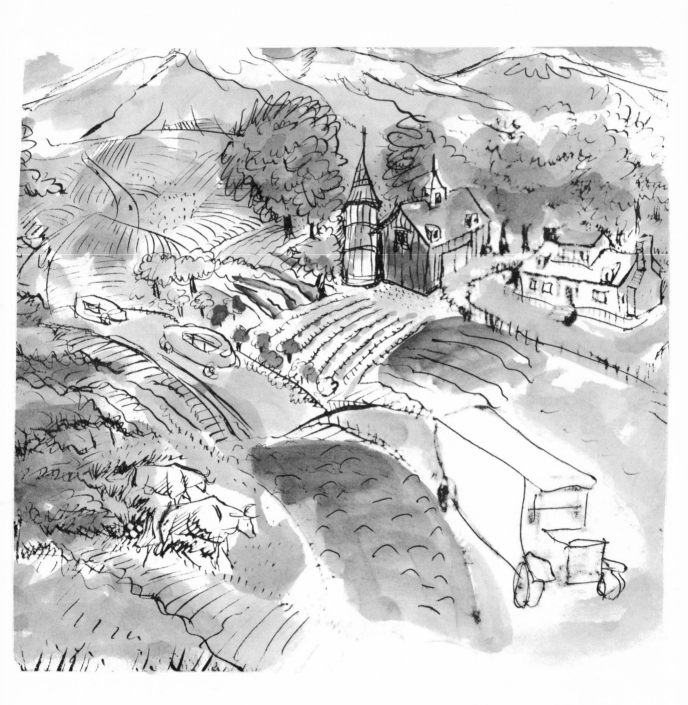

Another tinted drawing.

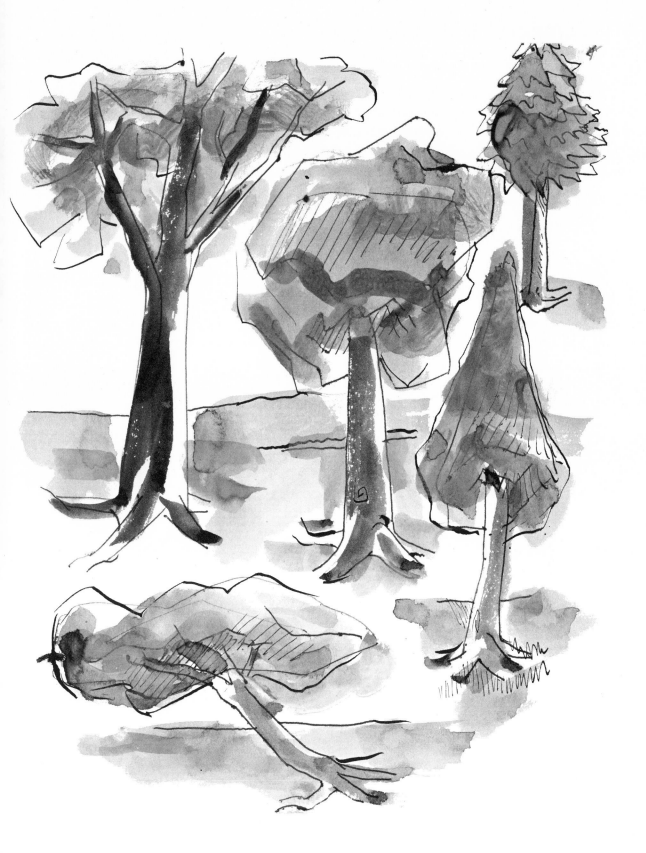

Another sketch with almost no underdrawing.

WATER-COLOR PENCILS

A delightful new method of making water-color *sketches* has become quite popular. That is the use of water-color pencils.

They are sold in convenient boxes, usually with about a dozen different colors.

They resemble ordinary color pencils except that when water is brushed onto the pencil line, the line blends into a transparent water-color flow.

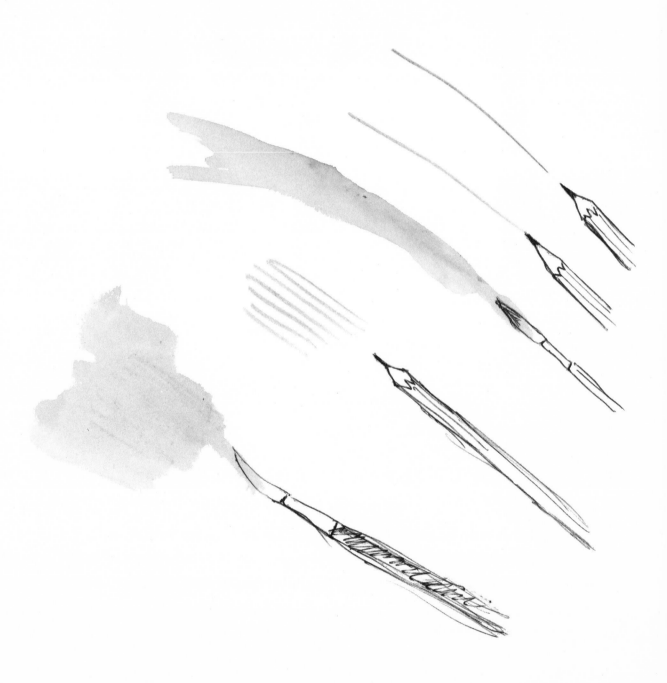

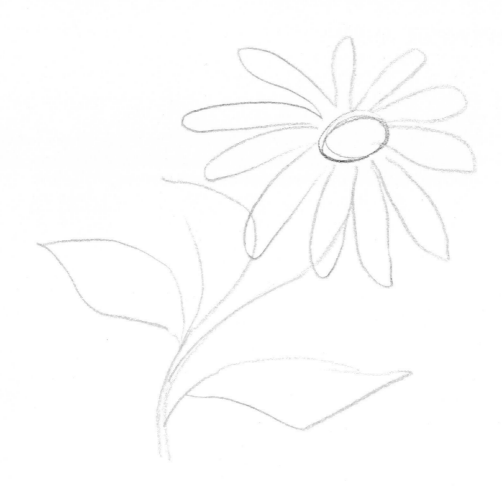

THE METHOD OF USING WATER-COLOR PENCIL

1. The pencils may be sharpened to a fine point for delicate strokes or to a relatively blunt end for broad, bold strokes.

For even heavier lines, the blunt point may be dipped in clear water.

2. Draw lightly the *outlines* of the subject you are going to paint, using the color pencil required for each area, with its point rather fine.

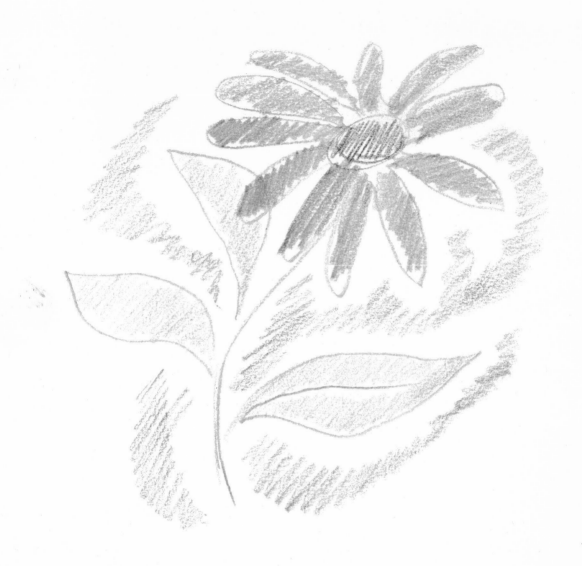

3. With the more blunted point, fill in such areas of your drawing as will require an even tone of color with a solid, even covering of pencil strokes.

4. Using several brushes of various heaviness, begin the "painting." Dip your brush in clear water and shake off the excess so that you don't drown the colors in an uncontrollable flow of water.

Flow water over your pencil lines until they lose their pencil character and become water-color washes.

Wash your brushes so they will be fresh with each blending. In some cases, you will want to blend edges of adjoining colors; in others, you may want to leave a sharp separation.

A FINAL WORD

You have now dipped just a little into the delightful process of making water colors.

Only long experience and constant practice, accompanied by love for your painting, will produce the best that is in you as a water-colorist.

Every minute of it is worthwhile. You may never become a great artist (on the other hand, you might!) but, whatever happens, you will have much fun and perhaps give a great deal of pleasure to others with your work.

Good luck and good painting to you.